SuperVisions
TOPSY-TURVY OPTICAL ILLUSIONS

Al Seckel

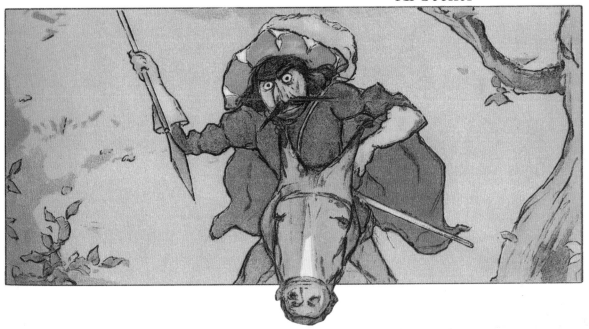

Sterling Publishing·Co., Inc.
New York

D1294658

Art/Photo credits, courtesy and copyright 2006 the artist:

p. 31 — Mitsumasa Anno

p. 15 — Arcimboldo, Museo Cireo Ala Ponzone, Cremona, Italy

p. 85 — Salvador Dalí, Gala-Salvador Dalí Foundation/Artists
 Rights Society (ARS), New York

p. 14 — Larry Kettlekamp

p. 12 — Scott Kim

p. 46 — Ken Landry

p. 87 — John Langdon www.johnlangdon.net

pp. 41, 74, 84 — István Orosz

p. 93 — R. Beau Lotto and Dale Purves,
 image by R. Beau Lotto www.lottolab.org

p. 77 — Oscar Reutersvärd. Author's collection

p. 5 — Roger Shepard

p. 63 — Gustave Verbeek

pp. 16, 46, 54, 65, 66, 69, 71, 76 — Rex Whistler

pp. 21, 79 — Walter Wick, from *Walter Wick's
 Optical Tricks.* Reprinted by permission of
 Scholastic Inc.

Book Design: Lucy Wilner
Editor: Rodman Pilgrim Neumann

Library of Congress Cataloging-in-Publication Data

Seckel, Al.
 Supervisions : topsy-turvy optical illusions / Al Seckel.
 p. cm.
 Includes index.
 ISBN 1-4027-1832-2
 1. Optical illusions. I. Title.

QP495.S4392 2006
612.8'4--dc22 2005024119

2 4 6 8 10 9 7 5 3 1

Published by Sterling Publishing Co., Inc.
387 Park Avenue South, New York, NY 10016
© 2006 by Al Seckel
Distributed in Canada by Sterling Publishing
c/o Canadian Manda Group, 165 Dufferin Street
Toronto, Ontario, Canada M6K 3H6
Distributed in Great Britain by Chrysalis Books Group PLC
The Chrysalis Building, Bramley Road, London W10 6SP, England
Distributed in Australia by Capricorn Link (Australia) Pty. Ltd.
P.O. Box 704, Windsor, NSW 2756, Australia

Printed in China
All rights reserved

Sterling ISBN-13: 978-1-4027-1832-8
ISBN-10: 1-4027-1832-2

For information about custom editions, special sales, premium and
corporate purchases, please contact Sterling Special Sales
Department at 800-805-5489 or specialsales@sterlingpub.com.

CONTENTS

INTRODUCTION

Inside this book, you will find the largest collection of topsy-turvy optical illusions ever assembled, which contains not only the familiar classics, but also many new and previously unpublished ones. Topsy-Turvy images have a different interpretation depending upon how much you rotate it. Some figures will need to be turned completely upside down and others only 90 degrees.

Topsy-turvy illusions have been popular since the sixteenth century, then they were used to conceal hidden messages and subversive political statements. In the nineteenth century, they had a renewed popularity, and there were many variations on invertible heads. In the early part of the twentieth century, there were several popular artists who created invertible comic strip characters, where you could read the story and then turn it over and read the second half.

Although in some sense, all the illusions in this book are puzzlers, they are not an intelligence test. These illusions are all meant to be fun! Share them with your friends, and watch how they won't believe their own eyes.

—Al Seckel

Glee Turns Glum

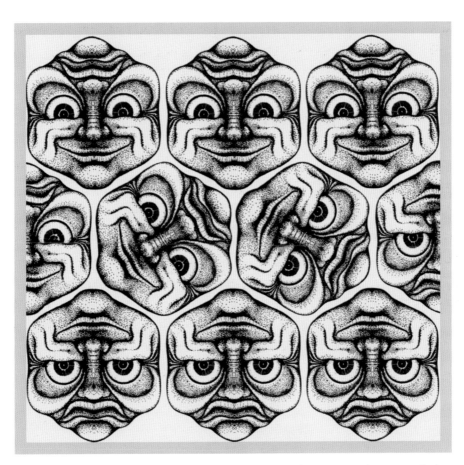

The top row of faces are in a happy mood, but as they rotate their mood changes.
The bottom row of faces, which is the top row inverted, looks positively glum.
Stanford psychologist Roger Shepard created this image.

Stop That Baby!

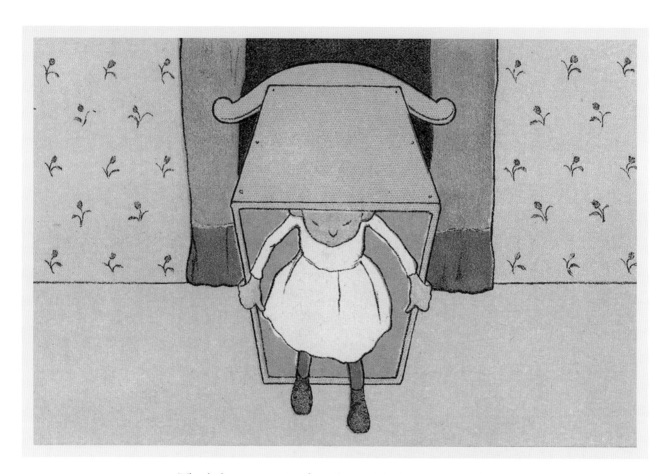

The baby is escaping from her crib! Can you stop her?

Vanishing Rabbit

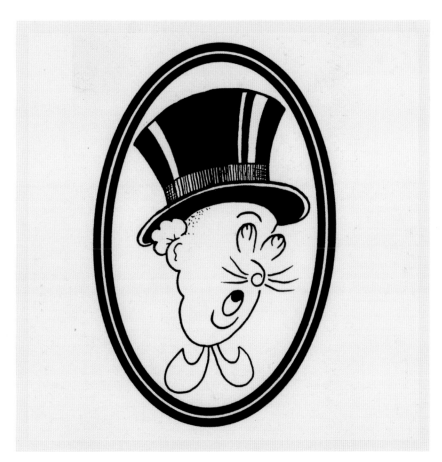

The magician has lost his rabbit. Can you find it?

Missing Donkey

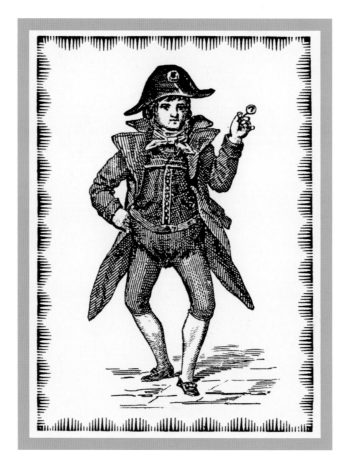

The man has lost his donkey. Can you find it?

Missing Clown

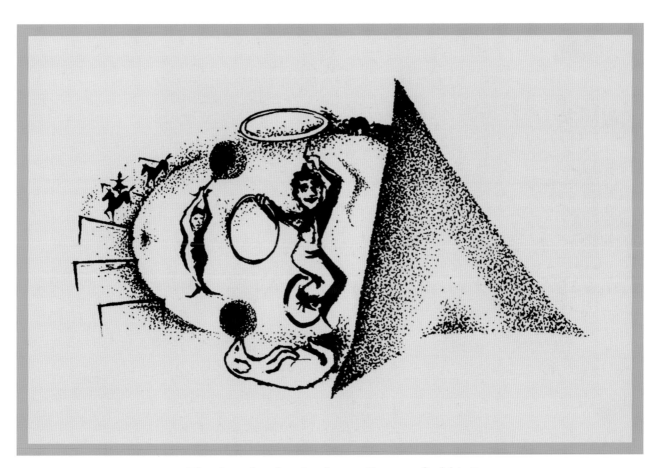

The circus has lost its clown. Can you find him?

Inverted Head Illusion

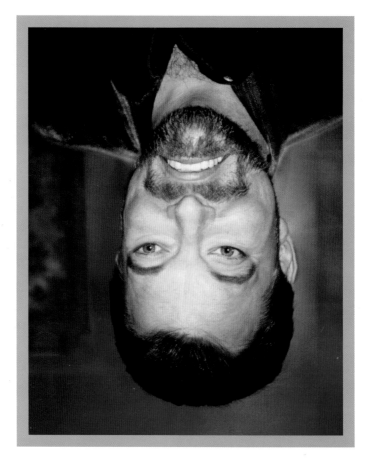

If you turn this upside-down face, it will be quite surprising!
Only the eyes and mouth are inverted on actor Jonathan Frakes.

Perfect Camouflage

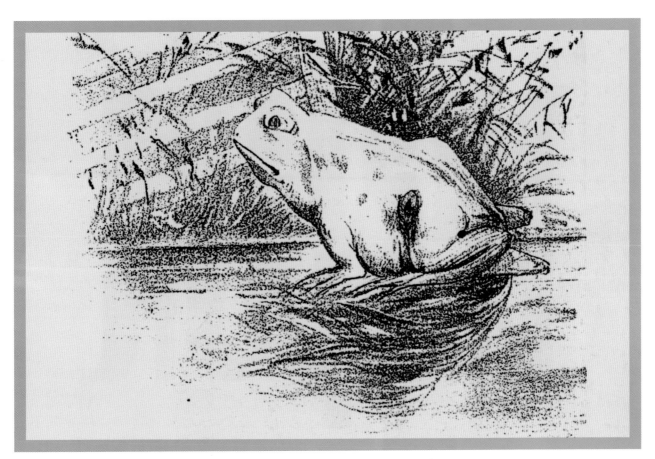

You can see a frog, but can you find the horse that is hiding?

Upside Down

What does this say when you turn it upside down?
This inversion was created by Scott Kim.

Jastrow's Duck/Rabbit Illusion

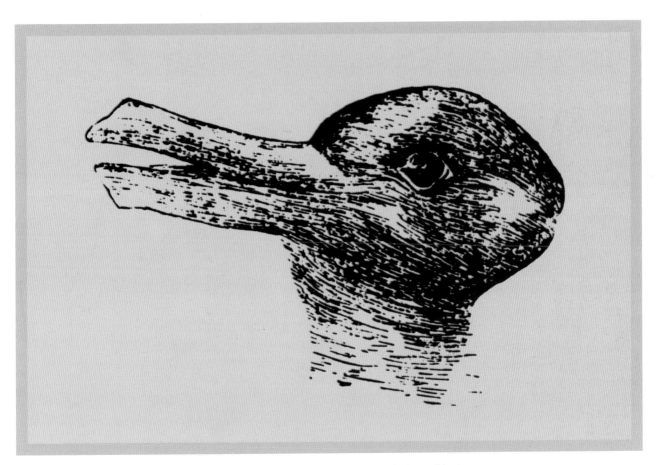

Can you find both the duck and the rabbit?

Portrait of Washington

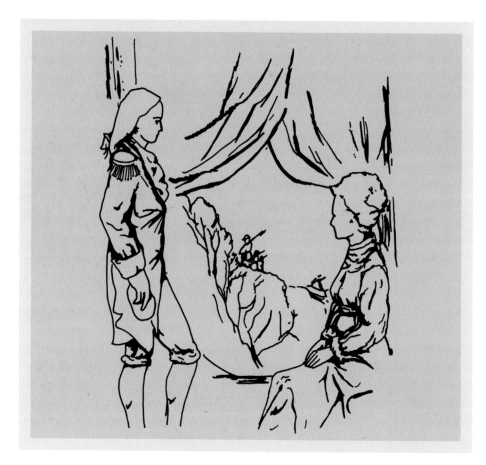

Can you find the hidden portrait of George Washington?
Larry Kettlekamp created this topsy-turvy.

Vegetable Gardener

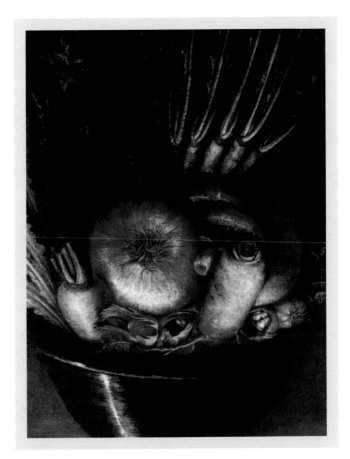

Here is a bowl of fruit. Can you find the hidden portrait? Sixteenth-century Italian artist Guiseppe Arcimboldo created this inverted portrait.

Surprise!

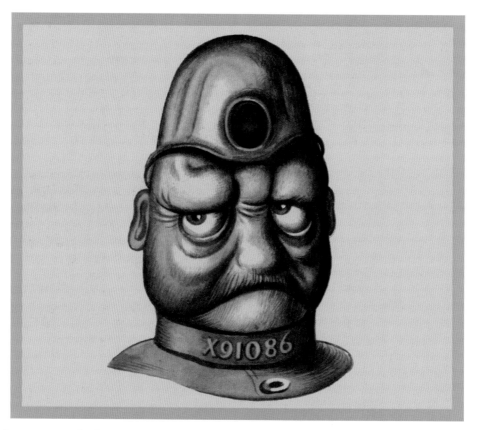

Turn this policeman upside down, and he will look surprised. English muralist Rex Whistler created many wonderful topsy-turvy images in the 1940s, which were published in a delightful book appropriately titled OHO. Other examples by Whistler can be seen on pages 47, 54, 65, 66, 69, 71, and 76.

Lie Detector

Is this man telling the truth? The answer is written all over his face.

Bearded Girls

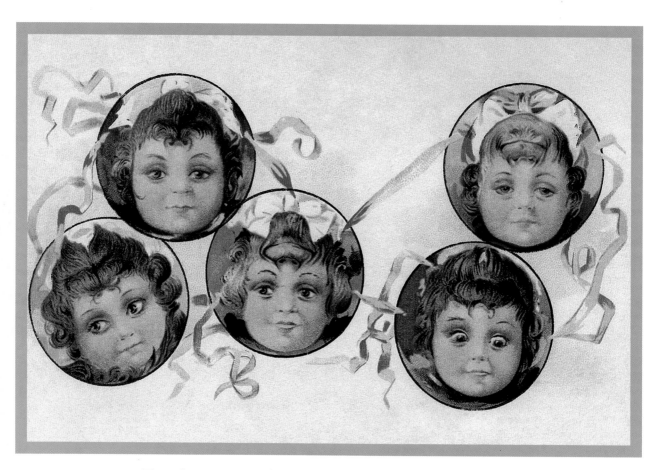

Turn this image upside down to turn the girls into bearded men.

Defeat of a Warrior

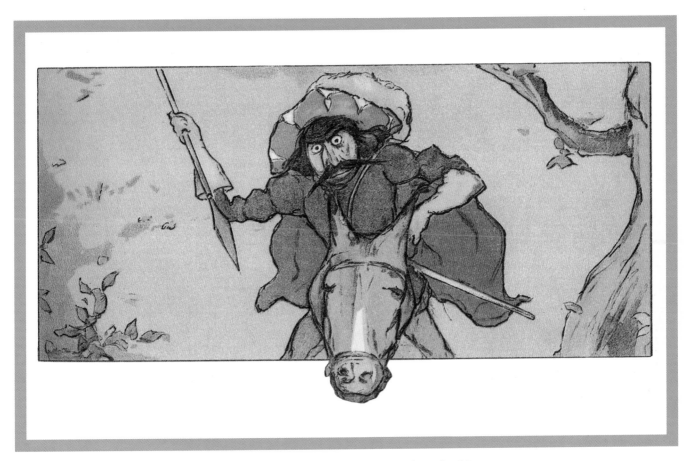

Can you defeat the warrior on horseback?

Cracking a Smile

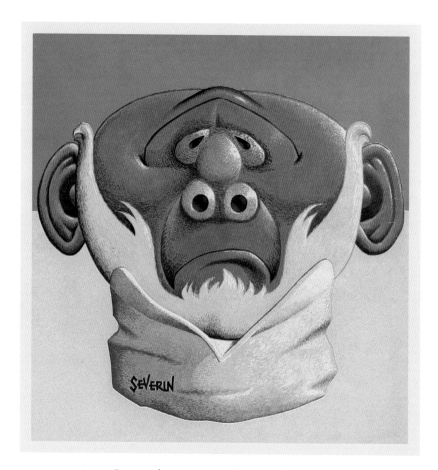

Invert the image to change the mood.

In or Out?

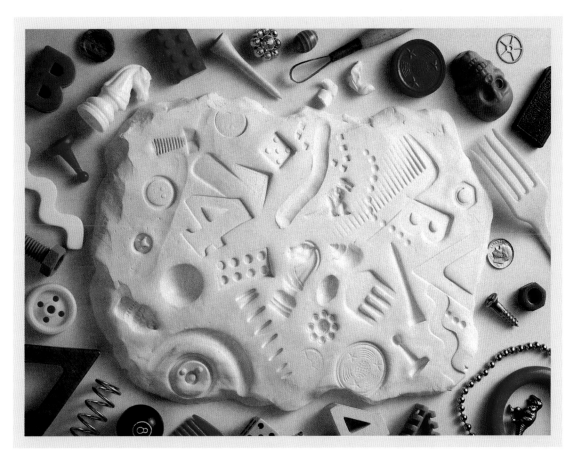

Turn the page and the indentations will appear to pop out rather than in. American photographer and famed children's author Walter Wick created this lovely shape from shading illusion. See another example by Wick on page 79.

Change of Character

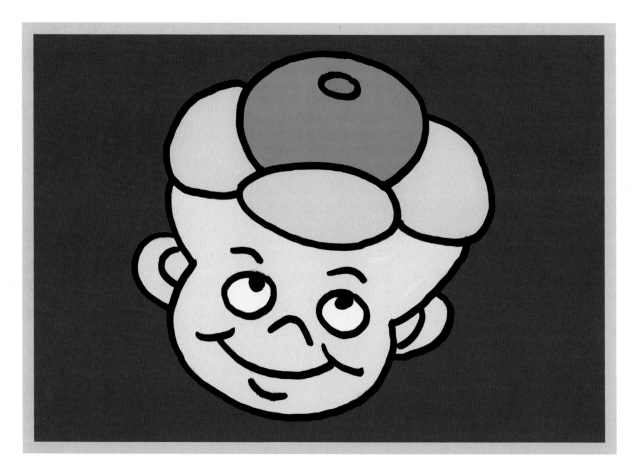

Invert the image.

He's Turning Green

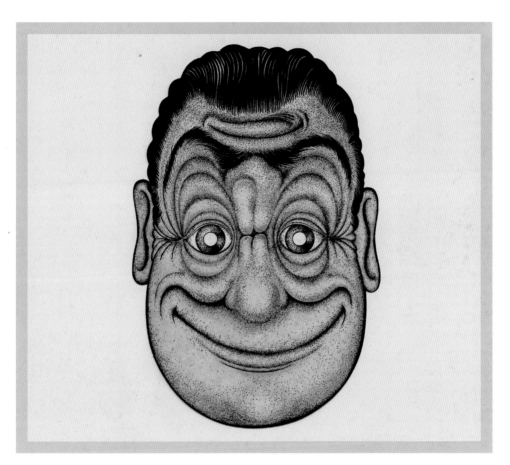

The man is green from being turned around constantly.

Eighteenth-Century Topsy-Turvy

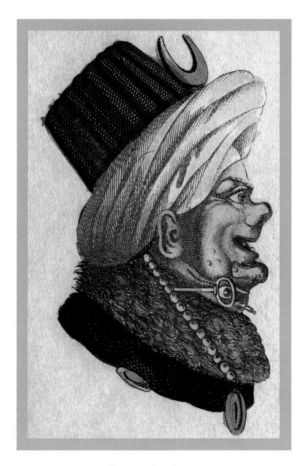

Invert the image.

Topsy-Turvy Head from Japan

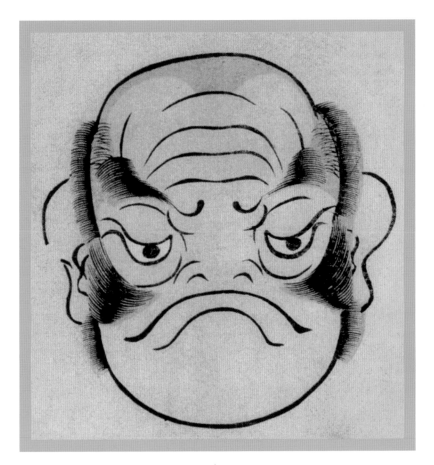

Invert the image.

Lost Passengers

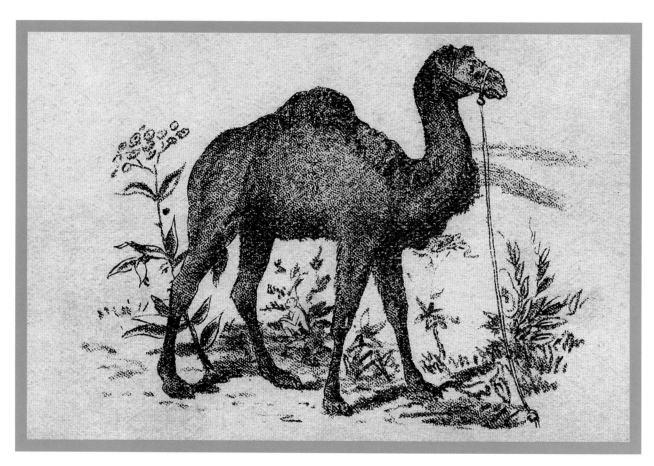

The camel seems to have lost its riders. Can you find them?

The Princess and the Hag

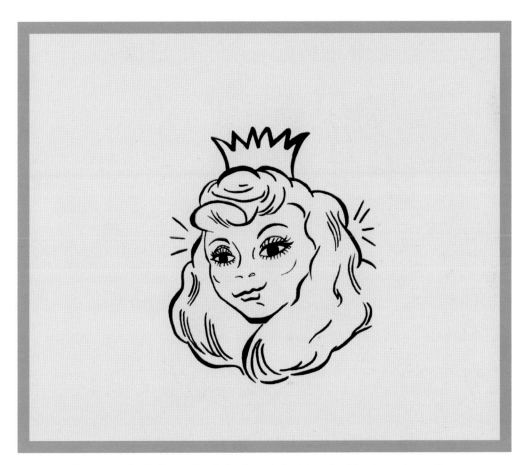

Can you find the evil witch that is lurking inside the princess?

Handstand

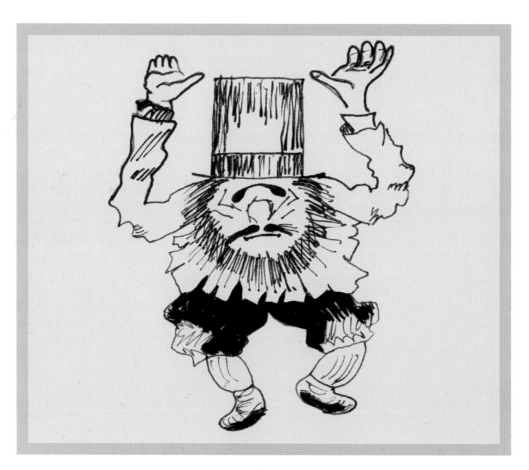

Invert the image.

Missing Hat

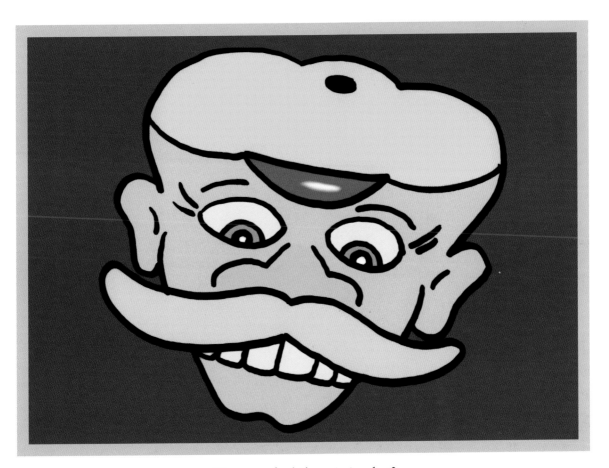

Can you find the missing hat?

Topsy-Turvy Coin

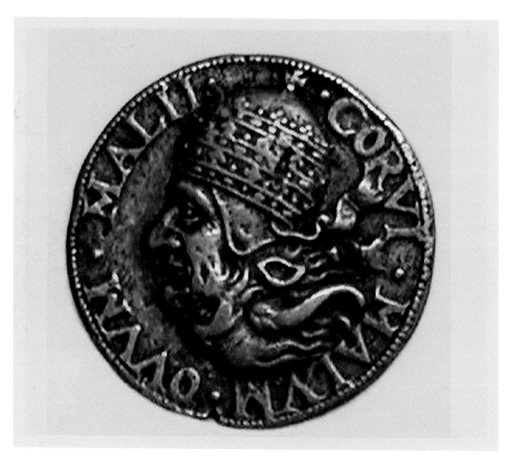

This is a topsy-turvy coin from the sixteenth century.

Anno's Upside-Down Village

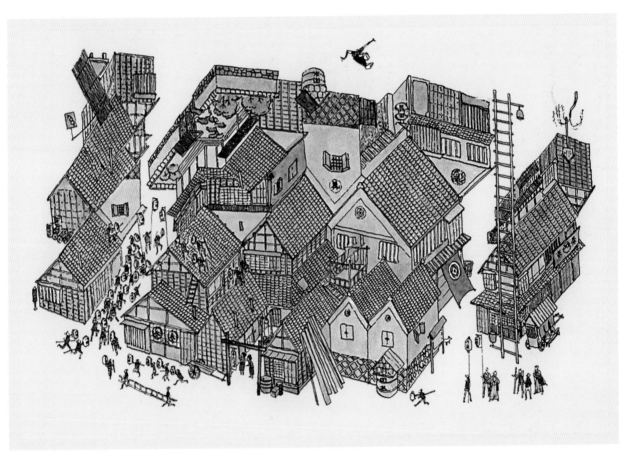

*This town can even defy gravity. Famed Japanese children's author
and illustrator Mitsumasa Anno created this inverted village.*

Missing Pie Piece

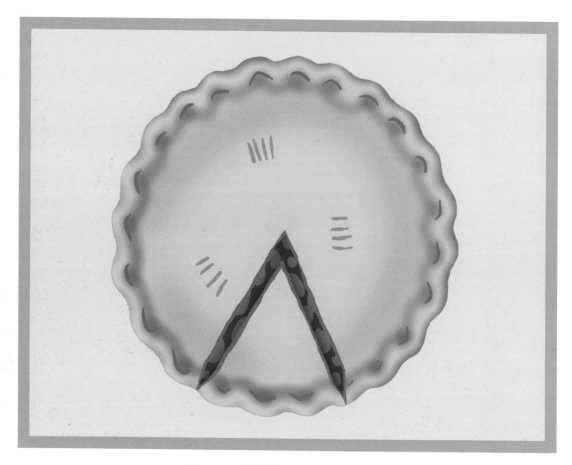

Can you find the missing pie piece?

Lost Captain

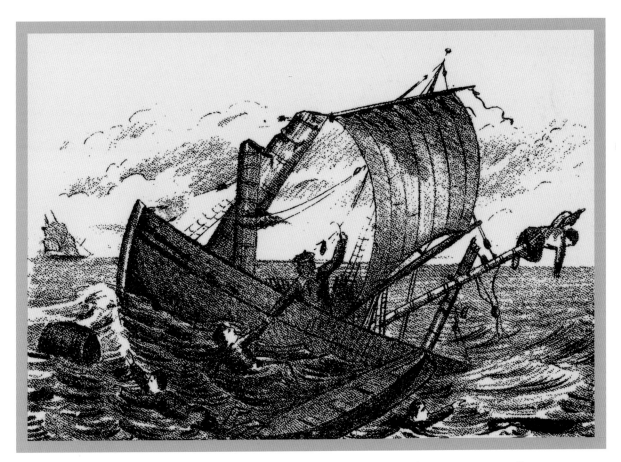

The crew has lost their captain. Can you find him? This image originally appeared on an American trading card published in 1880.

Santa's Hiding Place

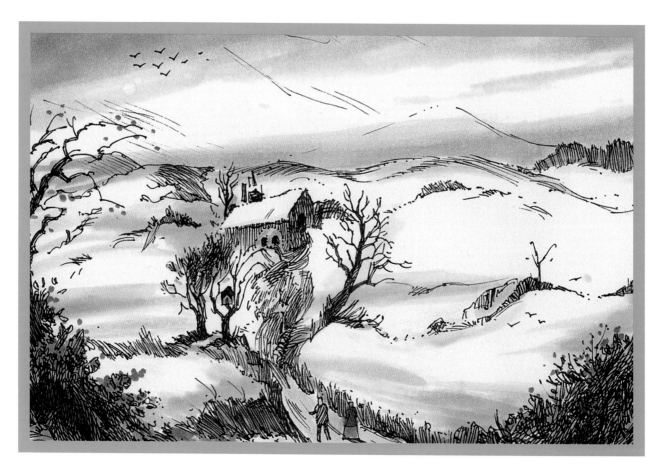

Can you find where Santa is hiding during the Christmas season?

Japanese Topsy-Turvy Head

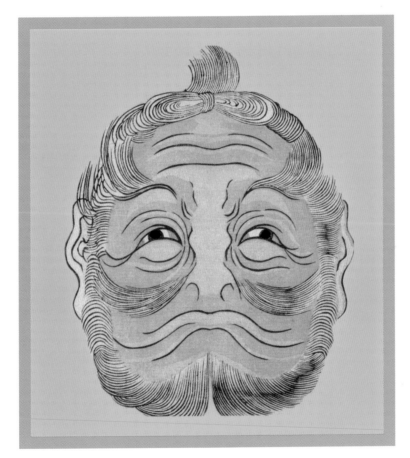

Invert the old man.

Danger Lurking

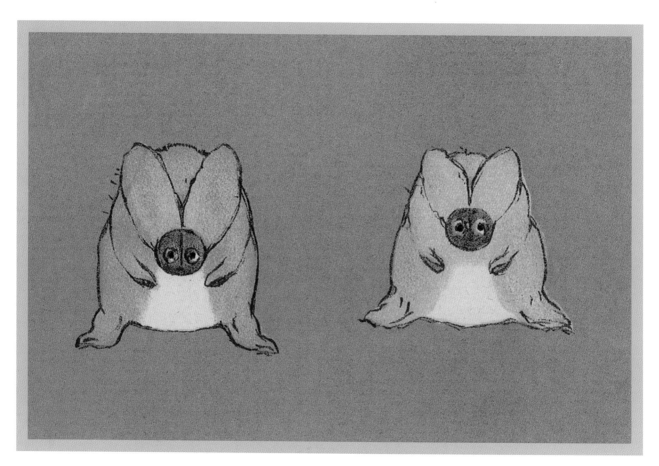

The pollywogs are happy, but there are dogs hiding! Can you find them?

Santa's Lost Pipe

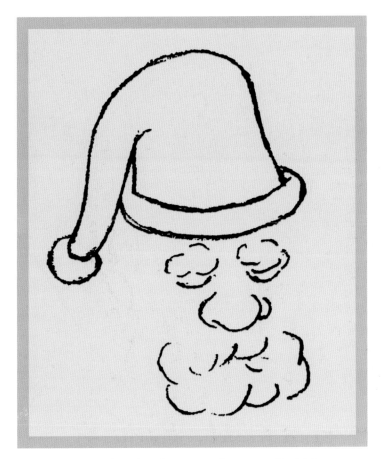

Santa has lost his pipe. Can you find it?

Invisible Jockey

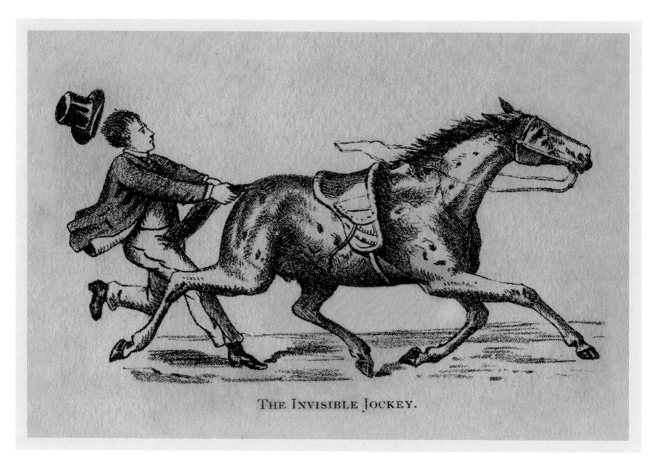

THE INVISIBLE JOCKEY.

The horse seems to have lost its rider. Can you find him?

Two Clowns

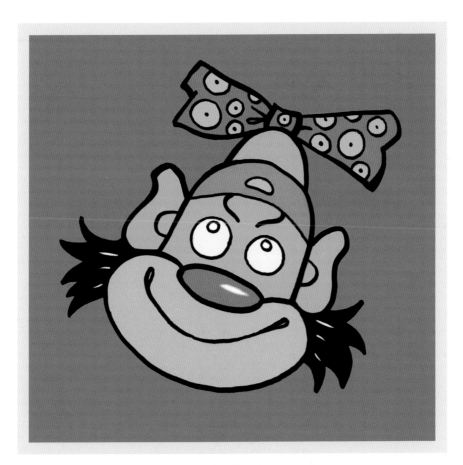

Can you find both clowns?

The Lost Friend

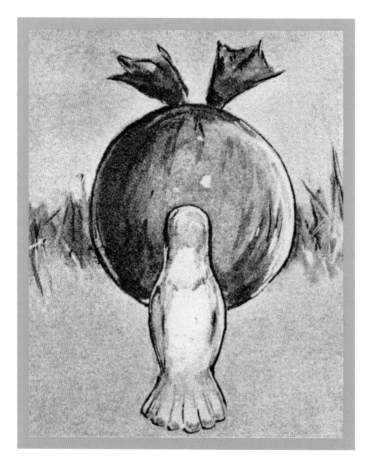

The pigeon lost his duck friend. Can you find him?

Hidden Portrait of Jules Verne

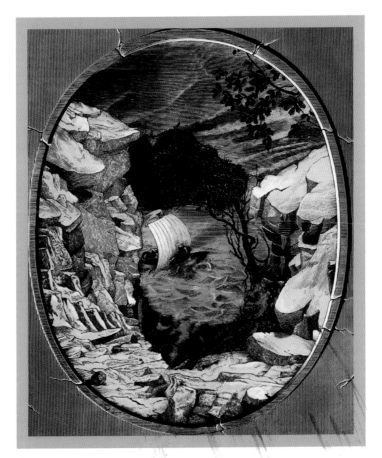

Can you find the hidden portrait of Jules Verne? Hungarian artist István Orosz created this inverted portrait.

Man in Camouflage

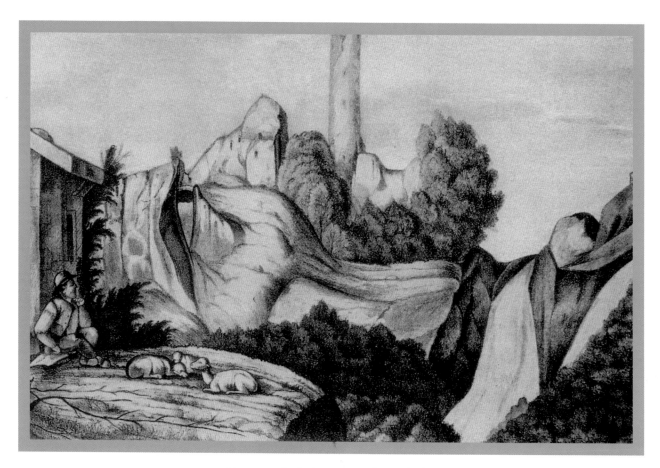

Can you find the man who is hiding?

Hats for Different Occasions

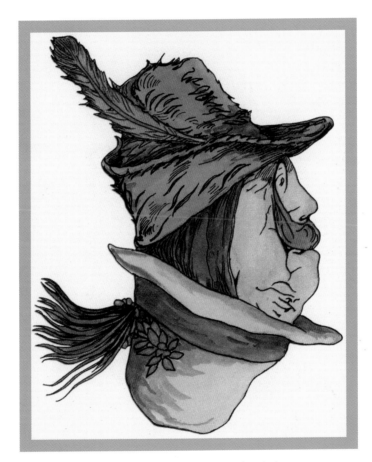

Invert the image to change the fashion.

A Change of Mood

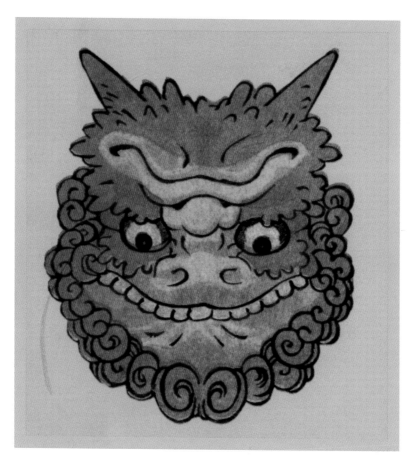

Invert the image to change the monster's mood.

No Laughing Matter

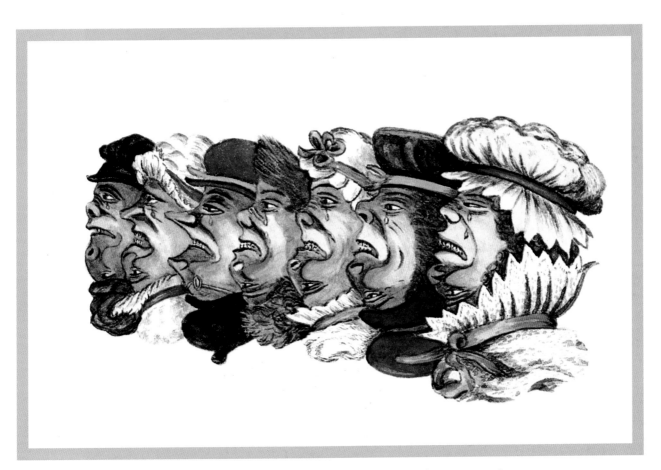

These people are sad. Can you make them happy again?

Tessellating Escher

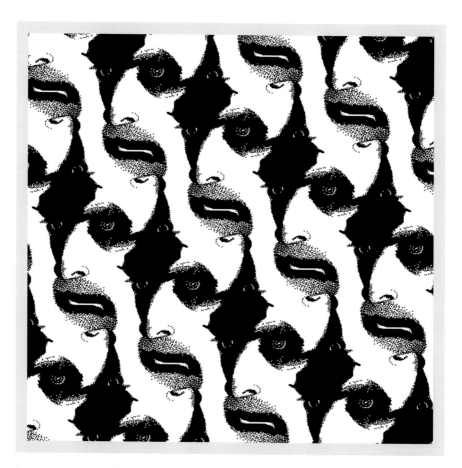

What do you see when you invert this portrait of illusion artist M.C. Escher?
American artist Ken Landry created this lovely tessellating inverted portrait.

Growing a Beard

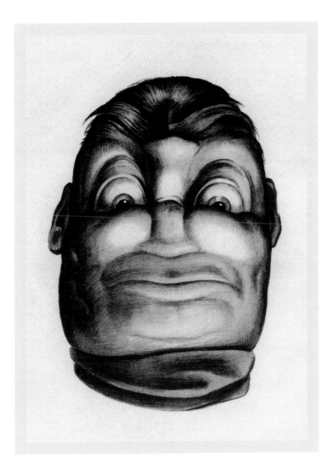

This man is thinking about growing a beard. Can you help him see what he would look like with one?

Peacock's Camouflage

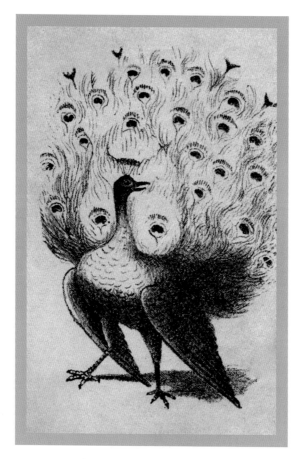

There is a man hiding here.
Can you find him?

Missing Pets

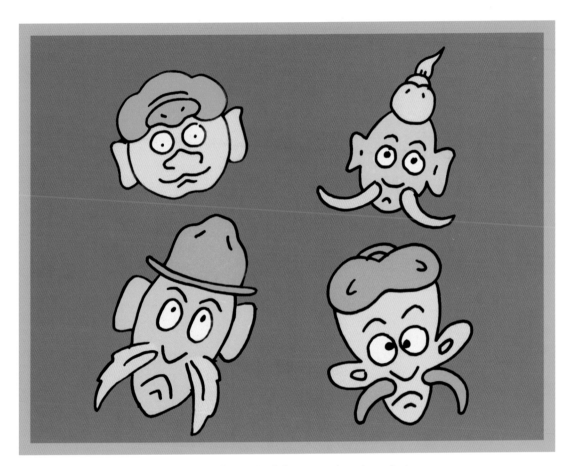

All these people are sad because they lost their pets.
Can you help find them?

French Eighteenth-Century Topsy-Turvy

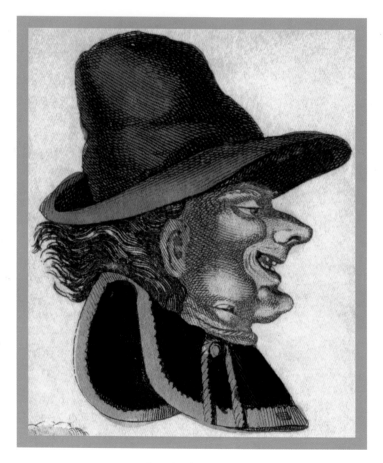

Invert the image.

Courtship and Matrimony

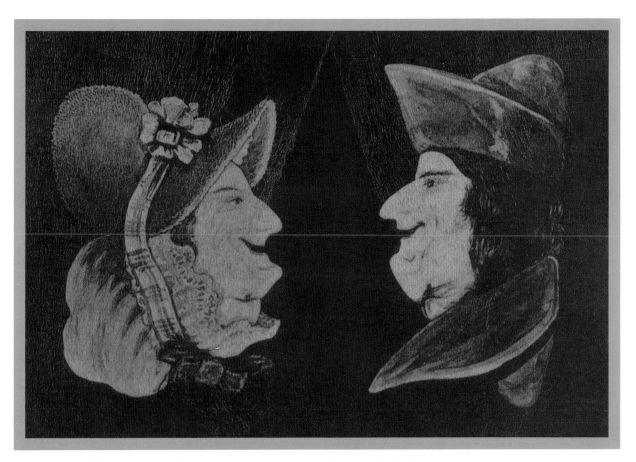

This nineteenth-century satirical image depicts life before marriage and after.

Lost Pet

This sad little girl has lost her pet. Can you help her find it?

Sudden Change of Mood

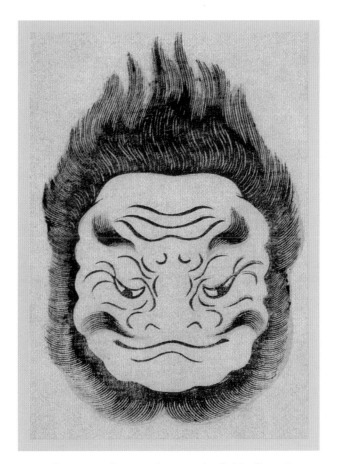

Can you change the mood of this figure?

Nosy Individual

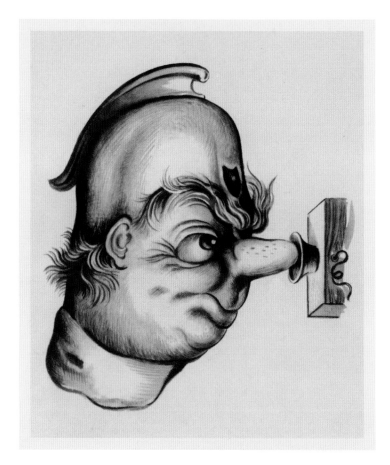

Invert the figure.

Farewell to Mussolini

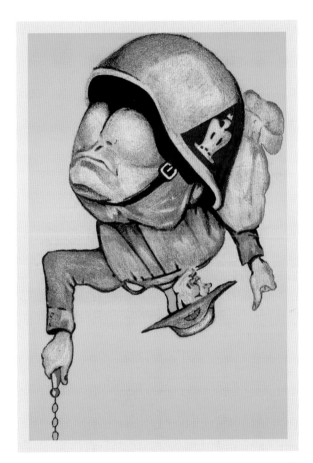

This image was created to celebrate Italy's deposing of the dictator Mussolini.

Hiding Out

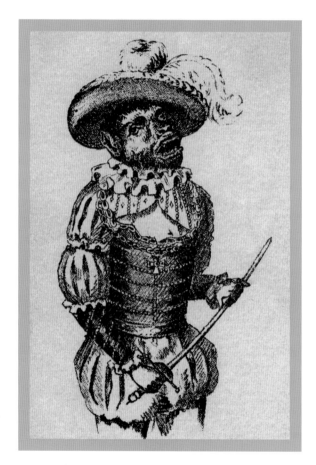

The woman is trapped by the beast.
Can you find her?

Gas Mask

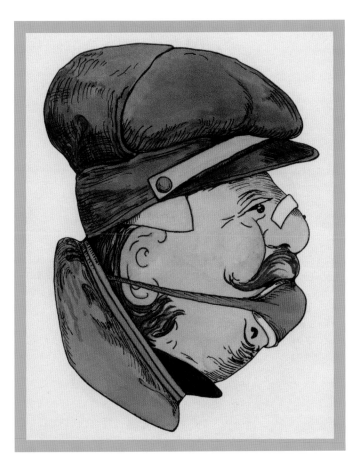

The man needs to clean up a smelly place.
Can you help him find his nose mask?

Losing Weight

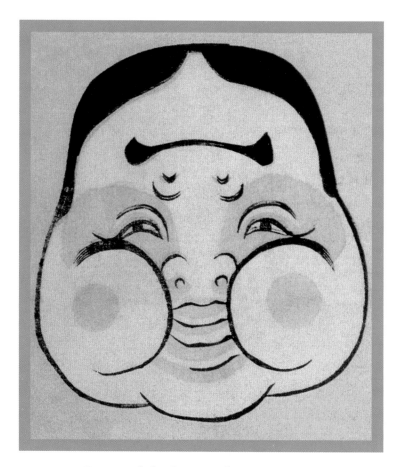

Can you help this man lose some weight?

Figure/Ground Illusion

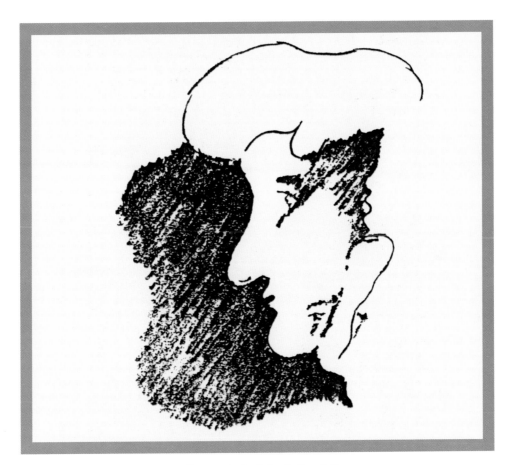

Can you find both heads?

Embarrassing Hair

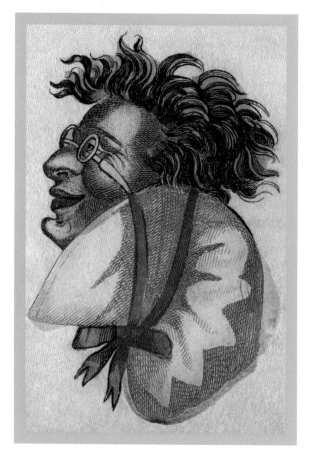

This woman is embarrassed about her hair.
Can you find a way for her to cover it?

Clowning Around

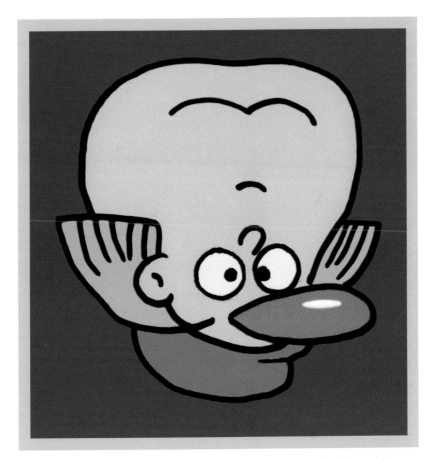

Can you make this man look less serious, and more like a clown?

Help Me!

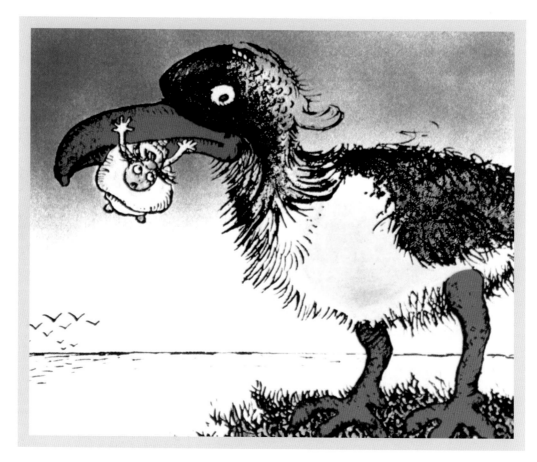

The poor little man is trapped by the bird. Can you find a way to help him escape? This image was part of an inverted comic strip by Gustave Verbeek.

A Change of Hats

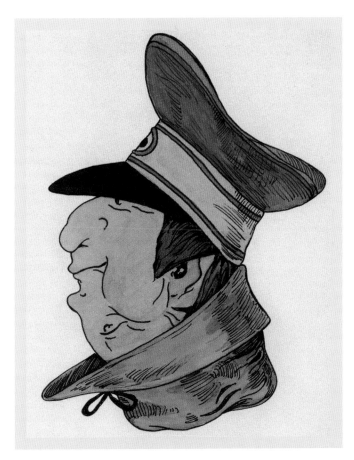

The man wants a different-colored hat.
Can you help him?

Growing Old

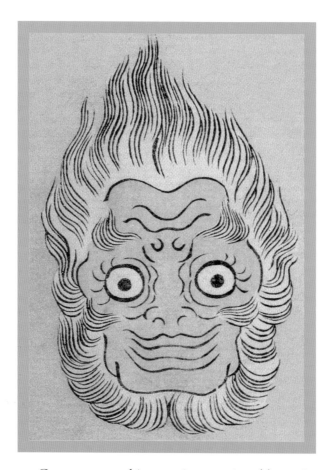

Can you turn this man into a wise old man?

Smile

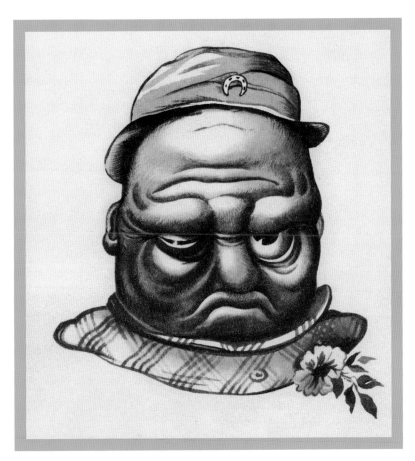

Can you make this man smile?

Growing Older

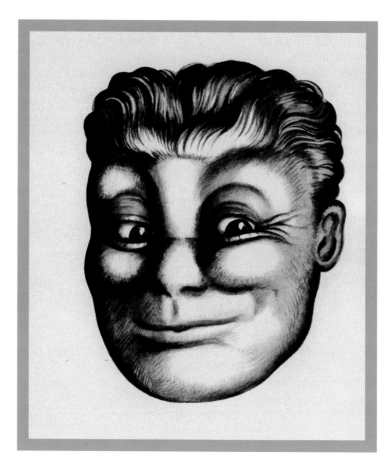

This boy wants to grow up.
Can you help him?

Teeth

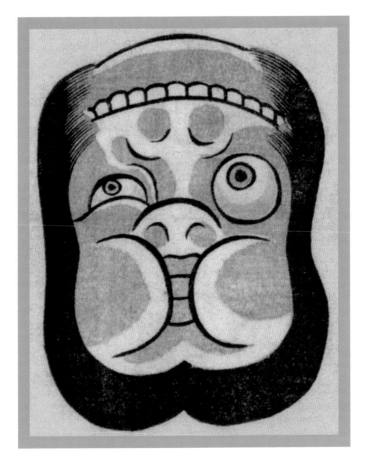

The dentist needs to check this man's teeth.
Can you get him to show them?

Growing a Beard

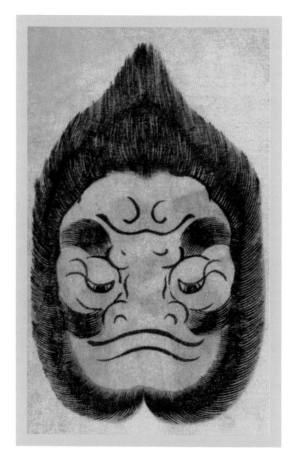

This man is not happy with the length of his beard.
Can you help him grow it?

Close Shave

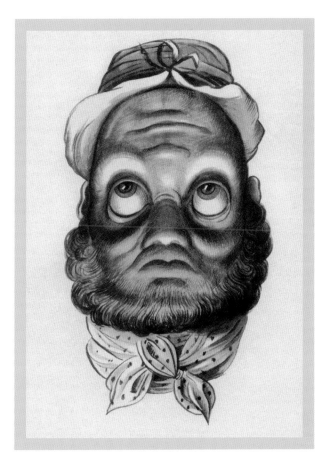

This man wants to shave his beard off. Can you help him?

Antique Topsy-Turvy

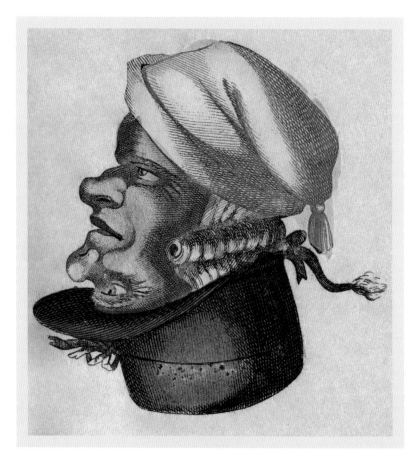

Invert the head.

Beauty and the Beast

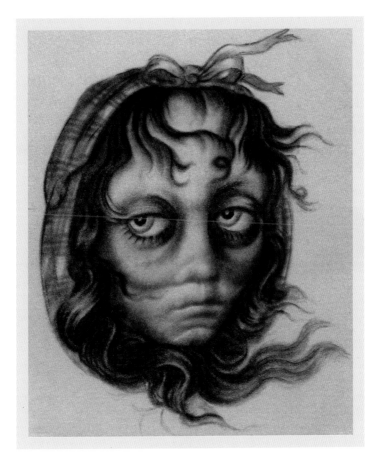

Can you find both the beauty and the beast?

Portrait in Fruit

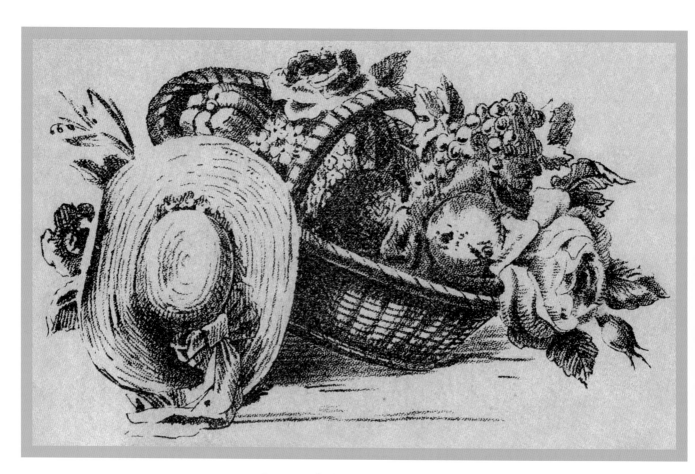

Can you find the hidden portrait?

Change in Fashion

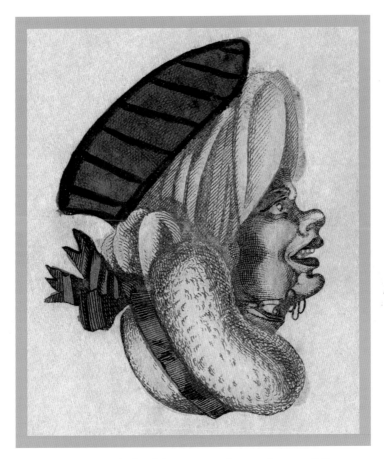

Can you help this woman change her outfit?

Hidden Head

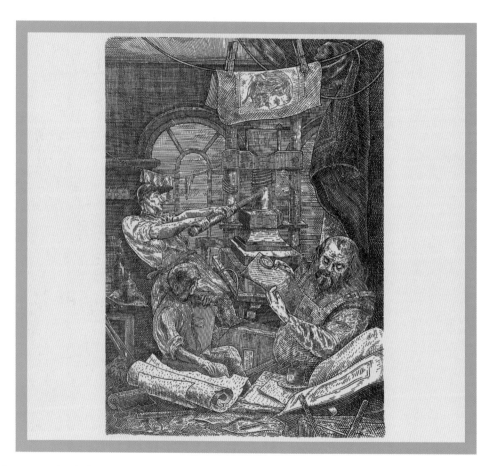

Can you find the hidden head? Hungarian artist István Orosz created this inverted portrait of the inventor of printing from movable type Johannes Gutenberg.

The Missing Turbin

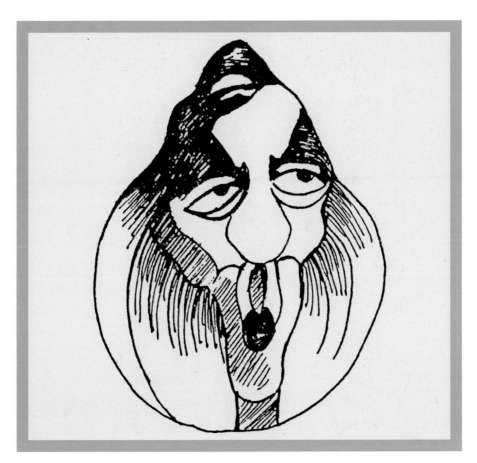

This man is not happy with the shape of his head.
Can you help him hide it?

The Missing Queen

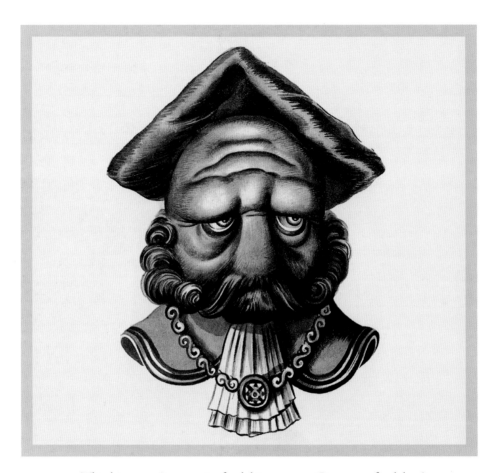

The king can't seem to find his queen. Can you find her?

Impossible Topsy-Turvy

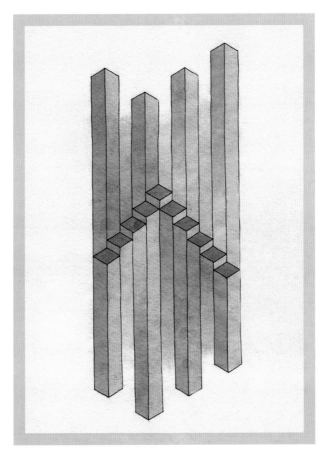

This figure is impossible even when you turn it upside down. Swedish artist Oscar Reutersvärd created this impossible topsy-turvy.

Cat Hiding in Its Own Shadow

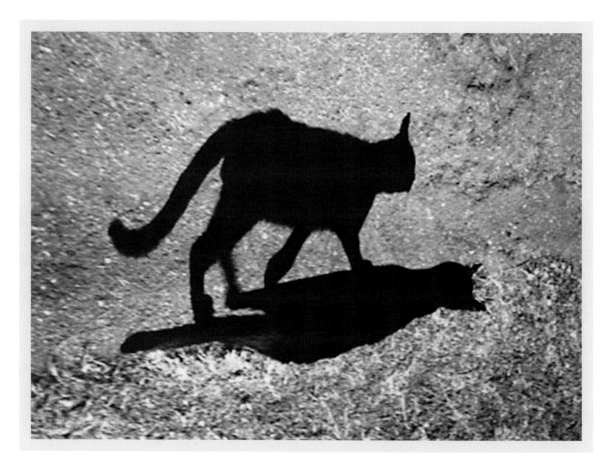

Which is the real cat, and which is its shadow? Turn the page to check.
American photographer Jerry Downs captured this strange scene.

Missing Deer

Can you find the missing deer? If you do, it should pop right out at you. Hint: Look at it from a distance after you have inverted it. American photographer and famed children's author Walter Wick created this lovely shape from shading illusion.

What Does This Man Look Like?

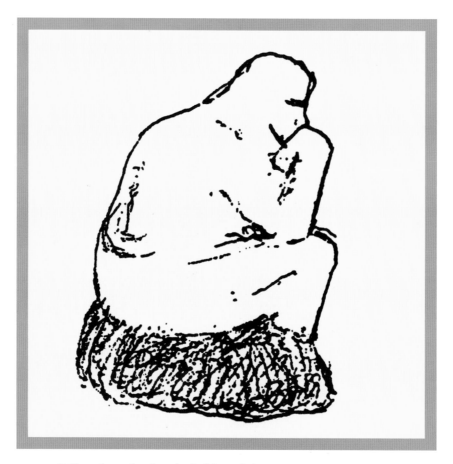

What does the face look like of the man sitting on a rock?

Flip-Flop Cube

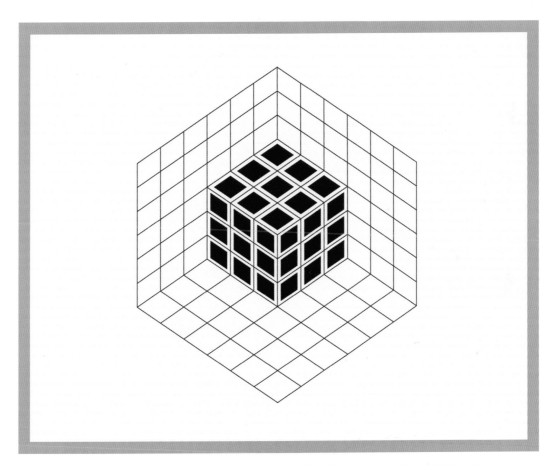

Turn this image upside down, and see what happens to the middle cube.

Out or In?

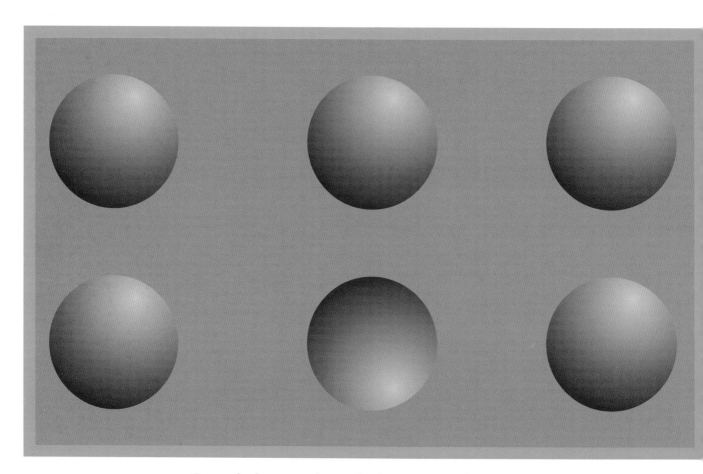

Count the bumps and turn the image over and count again.

Change of Expression

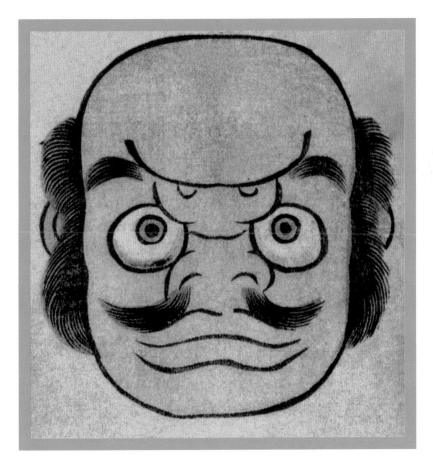

Invert the head.

Topsy-Turvy Staircase

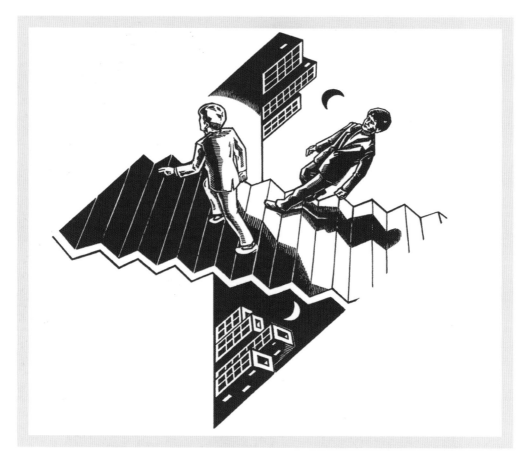

There is something strange about this staircase. Hungarian artist István Orosz created this strange set of stairs.

Island Man

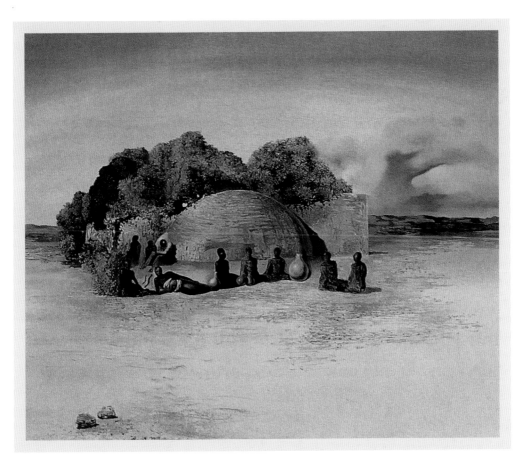

Can you find the missing man? Spanish surrealist artist Salvador Dalí created this ambiguous scene after he was sent a picturesque postcard by Pablo Picasso.

What Goes Up?

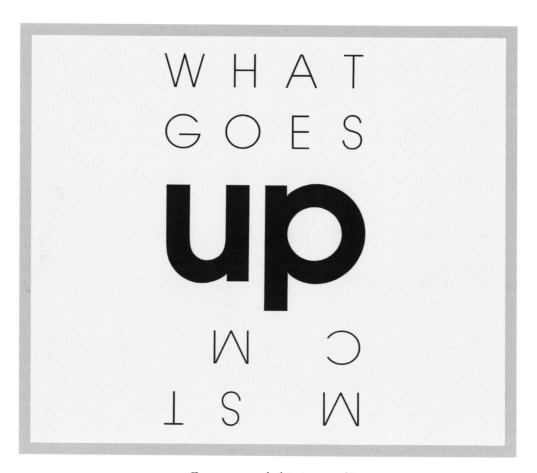

Can you read this inverted?

What Does This Say?

What does this say upside down? John Langdon created this inverted word.

Youth and Wisdom

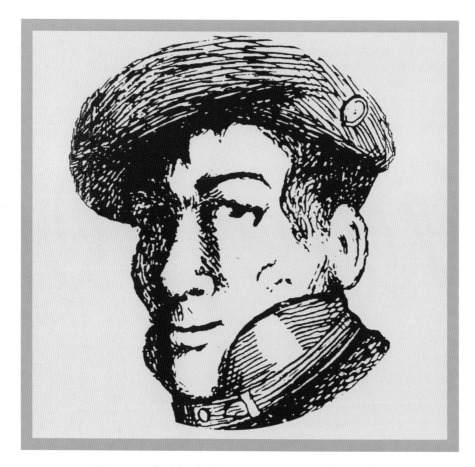

Can you find both the young man and his father?

Jokester

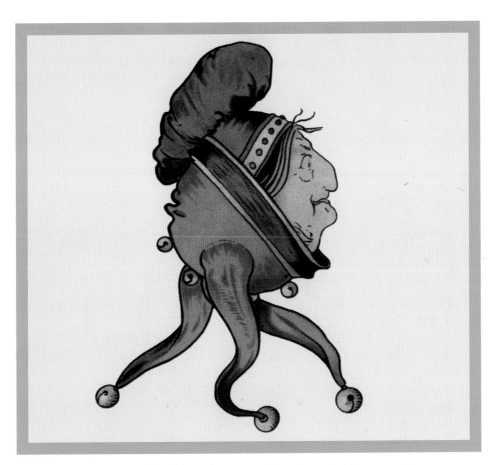

Can you find the jokester making fun of this woman?

A Hidden Portrait

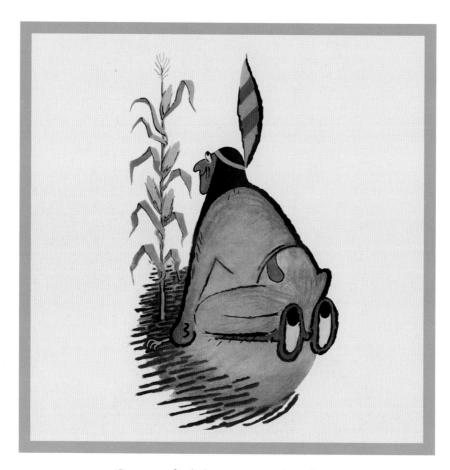

Can you find the man wearing glasses?

Goblet Illusion

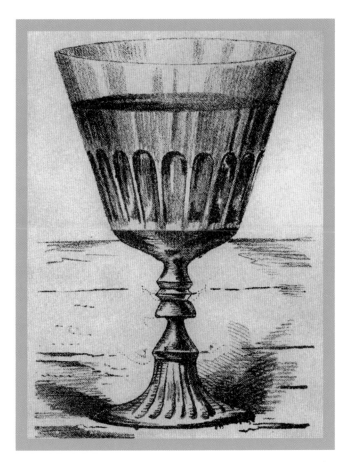

Can you find the two hidden profiles? This image, which appeared on an American puzzle card in 1880, was the inspiration for the famous figure/ground vase illusion that was made popular by the Dutch gestalt psychologist Edgar Rubin.

Lost Boyfriend

This woman lost her boyfriend. Can you help her find him?

Concave and Convex

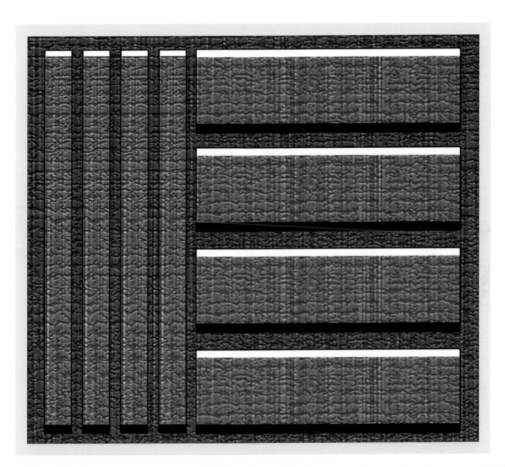

Are these blocks popping out or in? Turn it upside down, and see what happens. Duke University vision scientist Dale Purves created this shape from shading illusion.

Final Puzzle

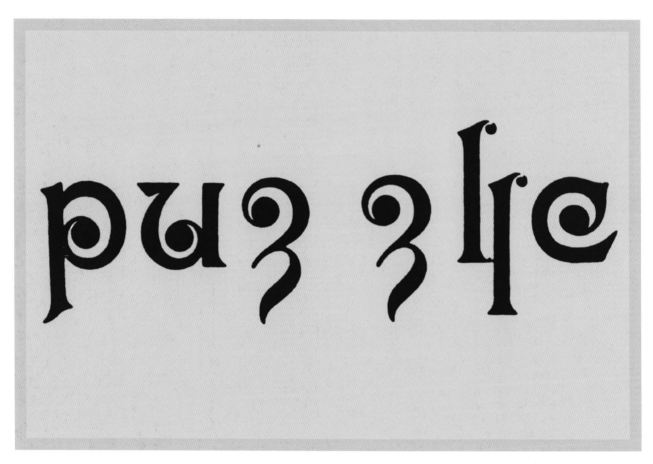

We wanted to leave you with one final puzzle. Can you figure out what it is?

INDEX

ABOUT THE AUTHOR

Al Seckel is the world's leading authority on visual and other types of sensory illusions, and has lectured extensively at the world's most prestigious universities. He has authored several award-winning books and collections of illusions that explain the science underlying illusions and visual perception.

Please visit his website http://neuro.caltech.edu/~seckel for a listing of all of his books on illusions.

Other Sterling books by Al Seckel:

Masters of Deception: Escher, Dalí & the Artists of Optical Illusion
SuperVisions: Action Optical Illusions
SuperVisions: Ambiguous Optical Illusions
SuperVisions: Geometric Optical Illusions
SuperVisions: Impossible Optical Illusions
SuperVisions: Stereo Optical Illusions